THE HAUNTED TEA-COSY

A Dispirited and Distasteful Diversion for Christmas

EDWARD GOREY

HARCOURT BRACE & COMPANY

New York San Diego London

The Haunted Tea-Cosy first appeared in the December 21, 1997
issue of *The New York Times Magazine*.

ISBN: 0-15-100415-3

Printed and bound in Mexico
B D F G E C

To the memory of Matthew Green

Edmund Gravel, known as the Recluse of Lower Spigot to everybody there and elsewhere, prepared to take tea by himself on Christmas Eve.

He was hardly able to cut a slice of fruitcake from the last one he had received more than a decade ago.

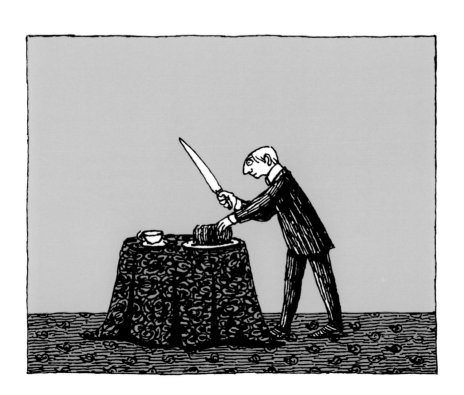

Waiting for the week's teabag to steep,
he wrote by hand several letters to
the newspapers anent the price of
a typewriter ribbon having risen
the day of the winter solstice.

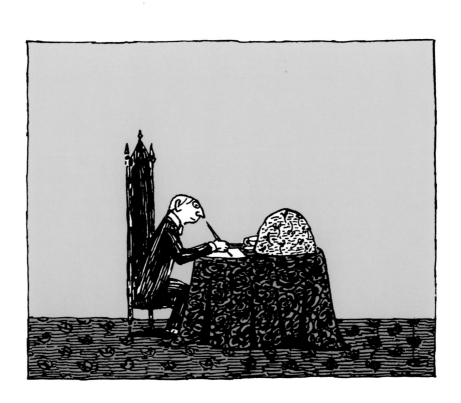

The tea-cosy suddenly twitched and from beneath it leapt a creature many times the size of the space within, even if it had not already held the teapot.

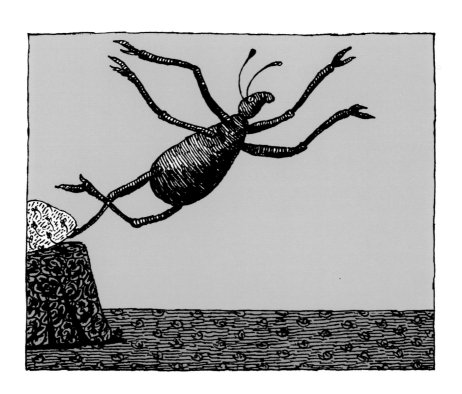

'I am the Bahhum Bug,' it declared; 'I am here to diffuse the interests of didacticism.'

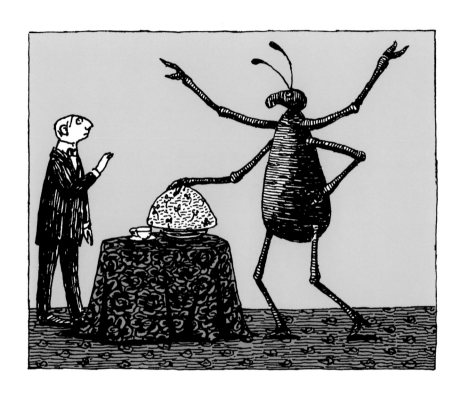

A knocking was heard at the door
through which, without it opening,
stepped a subfuse but transparent
personage.

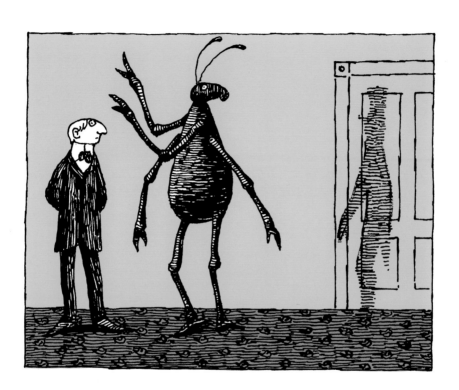

'I am the *Spectre of Christmas That Never Was*,' it muttered, 'and I have come to show you *Affecting Scenes*.'

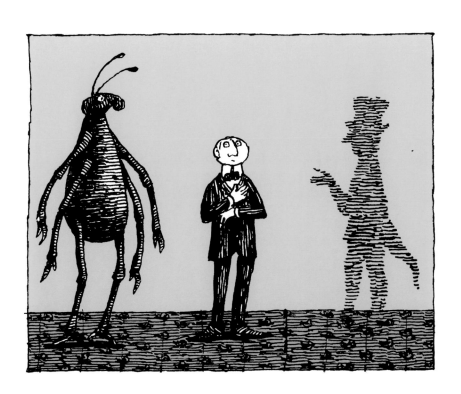

Gravel and *his companions found themselves* at *a great distance somewhere to the north*.

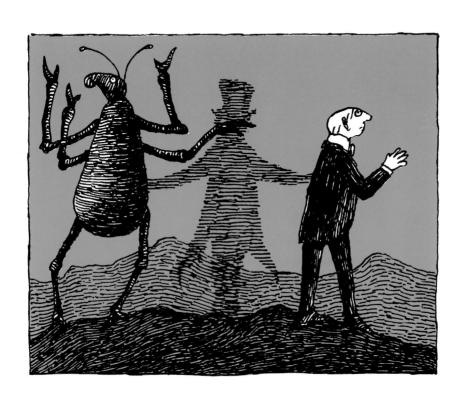

A small orphan called Nub and a
large stray dog named Bruno
huddled against a tombstone
whose inscription was worn away.

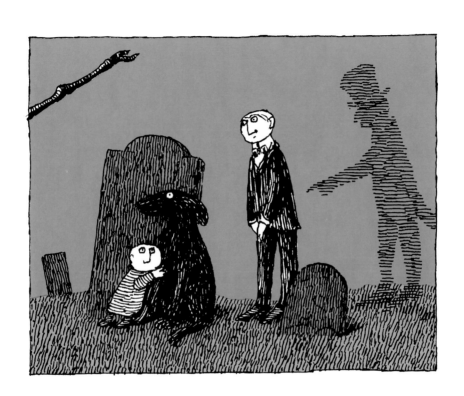

Across the road from the churchyard Alberta Stipple returned home to find the wallpaper in the drawing room gone.

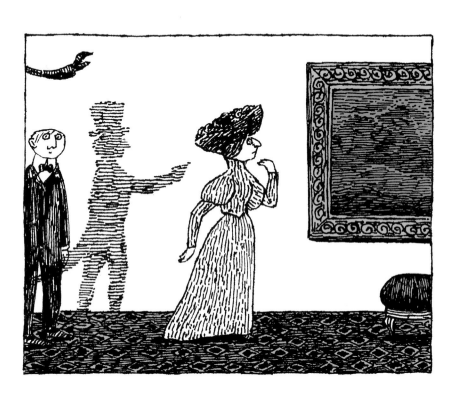

Three doors to the east the Edward Boggles could not agree whether the grandfather clock was fast or slow.

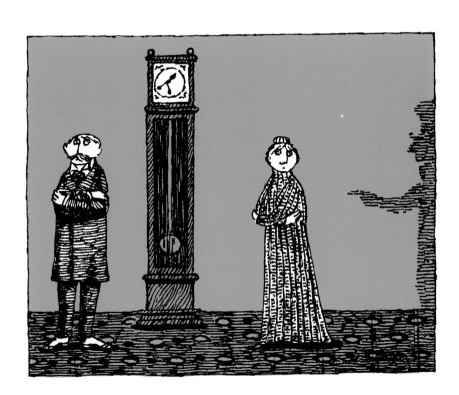

In the high street of the village
Reverend Flannel lost his tuning-
fork.

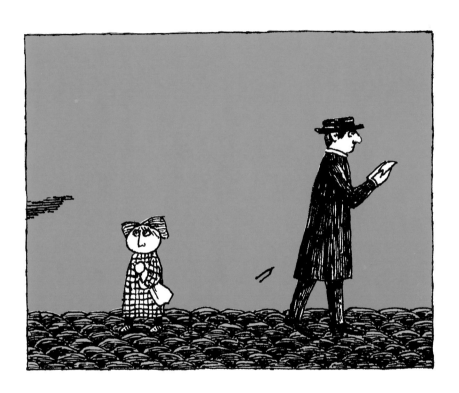

In the cottage next to the post office
Alma Crumble broke her wrist stirring
batter, at which the Bug declared
in a minatory tone that 'That was
enough of that.'

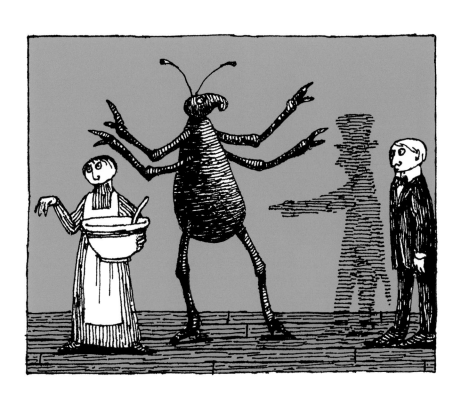

No sooner were they back than a
twittering was heard outside the
window through which, without
breaking the glass, drifted a second
subfusc but transparent personage.

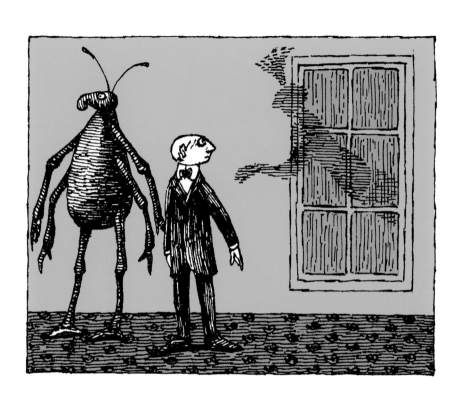

'I am the Spectre of Christmas That Isn't,' it murmured, 'and I have come to show you Distressing Scenes.'

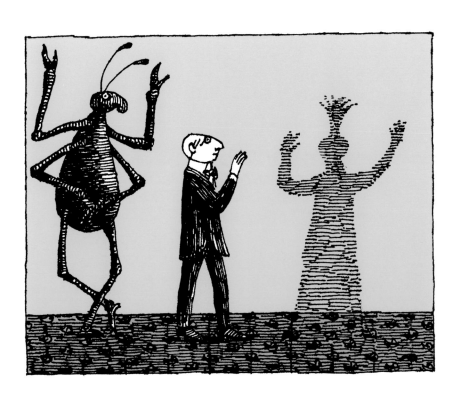

Albinia Fennel reclined on a chaise
longue and waited for a letter from
her brother in far-off Hokkaido,
Japan.

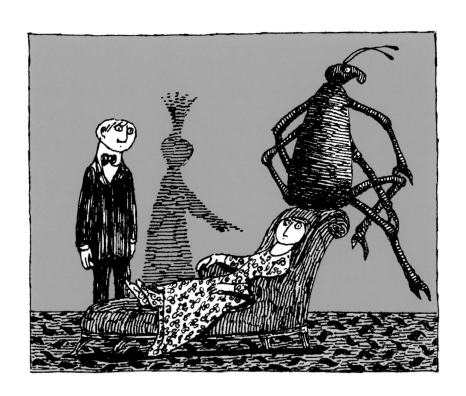

Over the way Alfreda Scumble was
abstracted from the veranda by
gypsies despite the barks of Nero.

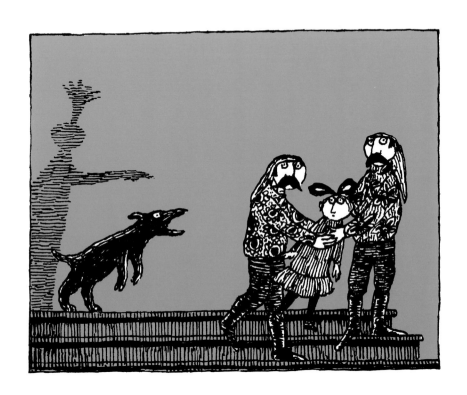

Next door but one the Edgar Grapples,
Senior and Junior, had an argument
as to what day of the week it was.

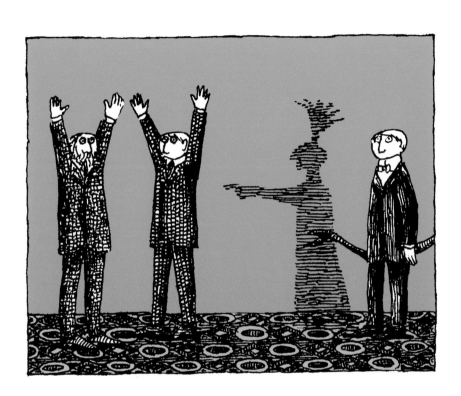

To the south, in the cemetery a wrong coffin in a newly dug grave was found to contain rolls of used wallpaper.

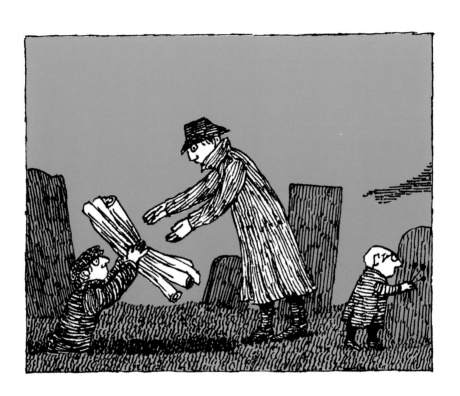

In a nearby villa Edo Haggle sprained his ankle while playing billiards, at which the Bug declared in an admonitory tone that 'That is enough of that.'

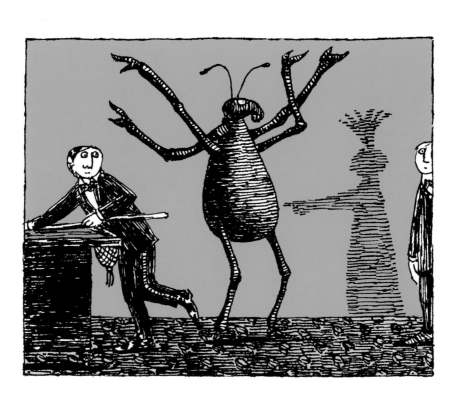

No sooner were they back than a
scratching came from under the floor
through which, without disturbing
the boards, ascended a third subfusc
but transparent personage.

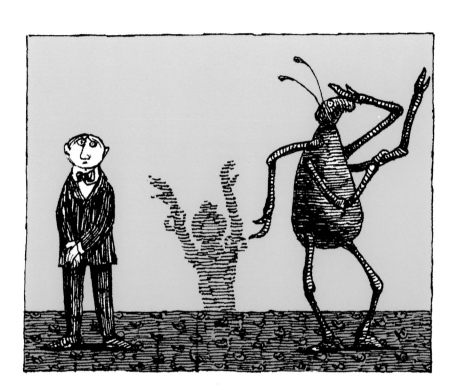

'I am the Spectre of Christmas That Never Will Be,' it mumbled, 'and I have come to show you Heart-Rending Scenes.'

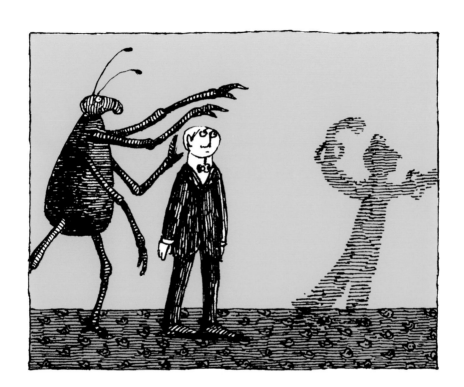

Alicia Grumble woke in the night
unable to think where she had put
her Bible.

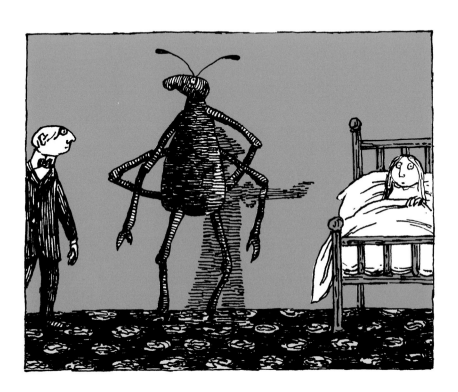

To the house opposite Fido was returned from the taxidermist and set down by the fireplace.

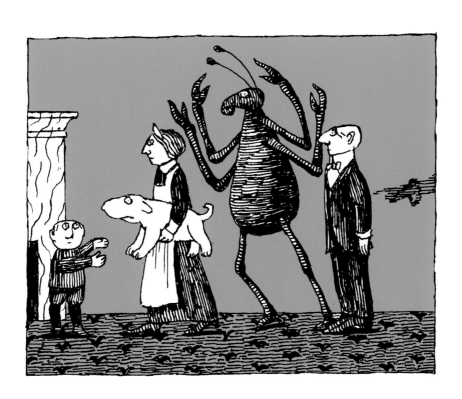

In a residence to the west Alethea Funnel lay on the sofa remembering her fiancé who had gone down with the Alexandra.

Beyond, at the ancestral home Lady Snaggle was informed her husband's were the brains behind an international gang of wallpaper thieves.

At the lodge Edwin Stopple, attempting to deal with a loose slate, fell off the roof, at which the Bug declared in an objurgatory tone that 'That will be enough of that.'

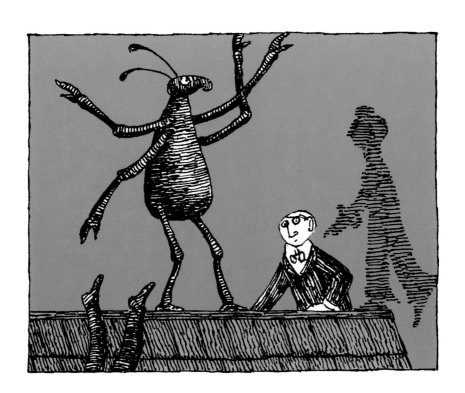

No sooner were they back than Gravel cried, 'I shall give a party and ask everyone in Lower Spigot and others from elsewhere,' and plunged into penning invitations.

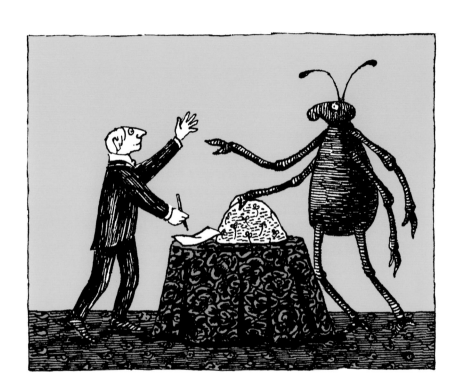

The cynosure was a cake taller
than anything else in the room,
a conflation of Chartres Cathedral
and the Stupa at Borobudur iced
in dazzling white sugar; inside
was a quarter-ton of fruitcake.

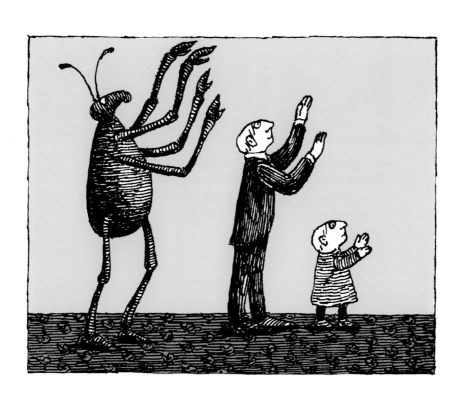

Giggling, dancing, and shrieking prevailed and, as the evening wore on, were carried to the very edge of the unseemly.

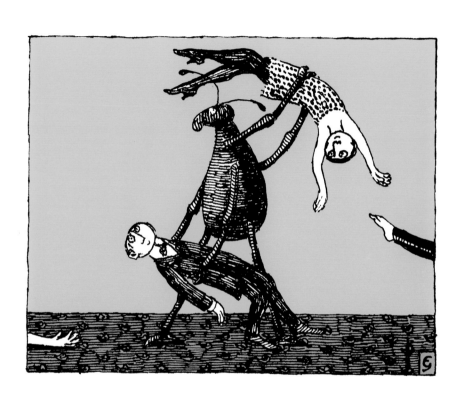